Chardin and Rembrandt

David Zwirner Books

ekphrasis

Chardin and Rembrandt
Marcel Proust

Translated by Jennie Feldman

Contents

6
Translator's Note
Jennie Feldman

10
Chardin and Rembrandt
Marcel Proust

25
Plates

42
Afterword
Alain Madeleine-Perdrillat

Translator's Note

Jennie Feldman

Proust once told an interviewer that style is "a quality of vision."[1] In "Chardin and Rembrandt" the blend of narrative, argument, and meticulous description reflects the author's desire for us to see what he sees in the works of these two masters; language is charged with conveying his response to them. It is precisely this preoccupation—the articulating of perception—that would dominate his *In Search of Lost Time*, first published in 1913, nearly twenty years after he wrote this essay. Proust's fascination with the interplay of art and reality, already evident here, also runs a connective thread through that novel.

Written when Proust was only twenty-four, "Chardin and Rembrandt" sometimes deploys generous, cumulative phrasing, but we are still a long way from *In Search of Lost Time*'s famously extended sentences with their proliferating sub-clauses, a style that accords with the more complex "vision" of the mature author. One key feature of this early essay that does anticipate the novel is its profound sense of the links between the things around us and our experience of them. Such rapports—Proust uses the term *amitiés* (amities or friendships)—are framed in Chardin's paintings: between a woman's spinning wheel and her feet, between the tablecloth and the light, "between people and things, the past and this life." This notion of interconnectedness generates many of the metaphors in the novel, and its protagonist Marcel is affected by perceived ruptures in the network of Baudelairean *correspondances*. We also find in the essay the assertion that art can help confirm something within us, which

points forward to Marcel's conviction, at the end of *In Search of Lost Time*, that "the recognition within himself, by the reader, of what the book is saying, is the proof of its truthfulness, and vice versa."[2] The loop between art and life is a dynamic one.

Proust's commitment to this three-way communication—between the writer/artist, his work, and the reader/viewer—lies at the heart of his aesthetic.[3] "Translation," in its widest sense, is the term he uses, notably in the final section of *In Search of Lost Time*, to denote the way in which art and literature can grant access to other worlds: "The writer's task and duty," he says towards the end of the novel, "are those of a translator" as he transcribes the book he has within him.[4] The notion of translation comes into play in this early essay, too: only through close observation, Proust says, can we translate all that an old person's face might teach, although with advancing age the face can fail to translate thoughts and emotions accurately. Art is the spur to an imaginative exploration of the inner worlds of others.

The beguiling urgency that propels "Chardin and Rembrandt" no doubt fed my own impulse, on discovering the work, to bring it to an English-speaking audience. This translation takes as its source the 2009 edition by Le Bruit du temps; Proust's original manuscript, first published posthumously in 1954, was left unfinished and untitled. In this English version, which stays close to the syntax and punctuation of the French, I have sought to keep Proust's exuberant tone and resonant cadences, as

well as the enlivening tension between direct address ("Now come to the kitchen") and an artful relishing of language as the young writer explores his literary prowess.

1 In an interview with Elie-Joseph Bois in *Le Temps*, November 13, 1913. English version in Marcel Proust's *Against Sainte-Beuve and Other Essays*, trans. John Sturrock (London: Penguin, 1994), p. 236.
2 Marcel Proust, *In Search of Lost Time*, vol. 6: *Finding Time Again*, trans. Ian Patterson (London: Penguin, 2003), p. 220.
3 See, for example, *Against Sainte-Beuve*, where reading is described as "the fertile miracle of a communication effected in solitude," p. 208.
4 Proust, *In Search of Lost Time*, vol. 6: *Finding Time Again*, p. 199.

Chardin and Rembrandt

Take a young man of modest means and artistic inclinations, sitting in his dining room at that banal, dismal moment when the midday meal has just finished and the table is only partly cleared. His imagination full of the glory of museums, cathedrals, sea, and mountains, he feels unease and ennui, a sensation close to disgust and akin to spleen, at the sight of a knife trailing on the half-hitched tablecloth that hangs to the floor, and next to it the remnant of a tasteless, undercooked cutlet. A little sunlight, falling on the sideboard and brightly glancing off a glass of water left almost full by lips whose thirst has been quenched, cruelly accentuates the traditional dullness of this unlovely sight, like an ironic chuckle. The young man sees his mother already sitting at work at the far end of the room, serene as always, slowly unwinding a skein of red wool. And behind her, perched on a cupboard beside a piece of bisque porcelain kept for "special occasions," a plump, squat cat seems to be the unimposing evil spirit presiding over this domestic mediocrity. As the young man shifts his gaze, it falls on the spotless, gleaming silverware and the glowing firedogs below. Irritated more by the room's tidiness than by the untidiness on the table, he envies financiers with fine taste who move only among beautiful objects, in rooms where everything, from the tongs on the hearth to the handle on the door, is a work of art. He curses the ugliness around him, and ashamed at having lingered for a quarter of an hour—feeling not so much shame as a kind of fascinated disgust—he gets up and, if he cannot catch a train to Holland or Italy, goes

to the Louvre in search of visions of Veronese's palaces, Van Dyck's princes, Claude Lorrain's harbors, which with evening will again become tarnished and irksome as everyday scenes return to their habitual settings.

If I were acquainted with this young man, I would not put him off going to the Louvre—indeed, I would accompany him; but leading him through the La Caze room and the gallery of eighteenth-century French painters, or any of the French galleries, I would make him stop in front of the works of Chardin. And when he is dazzled by this rich depiction of what he called mediocrity, this delectable portrayal of a life he found insipid, this great art showing a reality he considered paltry, I would say: So you're happy? Even though all you have seen is a well-to-do woman pointing out the faults in her daughter's embroidery (*The Diligent Mother*), a woman carrying loaves (*The Provider*), a kitchen interior where a lively cat steps on oysters while a dead ray hangs from the wall, a half-cleared sideboard with knives lying on the cloth (*Fruits and Animals*), not to mention table- and kitchenware, not just attractive pieces such as chocolate bowls made of Saxony porcelain (*Assorted Utensils*), but also those you consider the ugliest: a shiny saucepan lid, containers of every shape and material (salt cellar, skimming ladle), sights that you shrink from, dead fish lying on the table (*The Ray*), and sights that sicken you, glasses half-emptied and too many left full (*Fruits and Animals*).

If all these now strike you as beautiful to look at, it is because Chardin found them beautiful to paint. And he

found them beautiful to paint because he found them beautiful to look at. The pleasure you take in his painting of a room where someone is sewing, or of a pantry, a kitchen, a sideboard, is the same pleasure—seized in passing, detached from the moment, deepened, eternalized—that he took in seeing a sideboard, a kitchen, a pantry, or a room where someone is sewing. The two are so inseparable that if he was unable to content himself with the initial pleasure in what he saw and wished to give himself and others the second sort, then you cannot be content with only the second and will inevitably return to the first. The feeling of pleasure was already there in you, unconsciously, at the sight of a humble existence and scenes of still life, otherwise it would not have arisen within you when Chardin, in his brilliant, compelling language, happened to summon it. Your awareness, being too sluggish to reach down for such pleasure, had to wait for Chardin to take hold of it in you and raise it to a conscious level. That is when you recognized and savored it for the first time. If you can say, looking at a Chardin: this is as intimate and comforting and vital as a kitchen, then as you walk through a kitchen you will say: this is intriguing, this is grand, this is as beautiful as a Chardin. Chardin may have been someone who simply enjoyed spending time in his dining room, among the fruits and the drinking glasses, but he was a man with a sharper awareness, whose overly intense pleasure spilled into touches of oil and eternal colors. You will yourself be a Chardin, though no doubt less great—great to the extent that you love him and become

as he was—yet someone for whom, as for him, metals and stoneware will come to life, and fruits will speak.

Seeing that he has confided to you the secrets he knows from them, they in turn will no longer hold back from sharing these with you. Still life will become, above all, alive. Like life itself, it will always have something new to tell you, some marvel to highlight, some mystery to reveal; if you listen over several days to what his painting can teach, everyday life will delight you, and having understood the life within his painting, you will have mastered the beauty of life itself.

In rooms where you see nothing but the picture of other people's banality and the reflection of your own boredom, Chardin enters like light, giving each thing its color, summoning from the eternal darkness that had shrouded them all the creatures of still or animate life together with the meaning of each form, so striking to the eye, so obscure to the mind. Like the princess awoken from sleep, each is restored to life, recovers its colors, begins to converse with you, to live and to last. On that sideboard where everything, from the hurried folds of the partly lifted cloth to the knife left askew, protruding by a blade's length, everything recalls the servants' haste, everything bears witness to the guests' indulgence, the fruit dish—still as glorious as an autumn orchard and already as raided—crowned with peaches as pink and plump as cherubs, as smiling and inaccessible as gods. A dog lifts his head but cannot reach them, making them all the more desirable for being desired in vain. His eye relishes

them and catches upon their velvet skin the moistening sweetness of their savor. In glasses as clear as daylight, as alluring as fresh springs, a few mouthfuls of new wine linger as if in the throat while others stand next to them almost empty, like emblems of a burning thirst next to emblems of thirst assuaged. One has half-tipped over, leaning like a wilted corolla; the felicity of its angle reveals the tapered stem, its fine merger with the base, the transparency of the glass, its noble widening to the rim. Partly cracked and thus independent of the needs of men it will no longer serve, in its useless grace it takes on the nobility of a Venetian flagon. Oysters as light as cupped mother-of-pearl and as cool as the seawater they offer lie scattered on the tablecloth like delicate and delightful symbols on an altar to indulgence.

Still pitched sideways by the fleet foot that briskly jogged it, cold water in a pail spills onto the floor. A knife, quickly tucked away and showing the impetuousness of the pleasure taken, raises up golden discs of lemon seemingly placed there by the hand of indulgence, perfecting the display of sensuous delight.

Now come to the kitchen, its entrance strictly guarded by a tribe of vessels of all sizes, loyal and capable servants, a fine, industrious race. On the table keen knives that go straight to point lie about idly, menacing and harmless. But above you hangs a strange monster still fresh from the sea it rippled through—a ray, the sight of which infuses the appetite's desire with the strange charm of the sea's lulls and storms that had this impressive witness, as

if a recollection from the Jardin des Plantes had crossed with the savors of a restaurant. It has been cut open and you can admire the beauty of its vast and delicate architecture, tinted with red blood, blue nerves, and white muscle, like the nave of a polychrome cathedral. Next to it, fish in the abandon of death have twisted into stiff, desperate arcs, flat on their bellies, eyes bulging. Then a cat, superimposing on the obscure life of this aquarium its body's more knowing alertness, its gleaming eye fixed on the ray, slowly and nimbly maneuvers its velvet paws upon the piled oysters, revealing at one and the same time its cautious nature, its covetous palate, and the temerity of its venture. Since the eye likes to play with the other senses and to create, with the aid of a few colors, a whole future rather than a whole past, it already senses the coolness of the oysters that are about to dampen the cat's paws, and one can already hear, at the moment the delicate, precariously heaped mother-of-pearl gives way under the cat's weight, the slight rasp as they crack and tumble thunderously down.

Like commonplace objects, everyday faces also have their charm. There is pleasure in seeing a woman examine her daughter's embroidery, the one's eyes filled with the past, knowing and calculating and foreseeing, and the unknowing eyes of the other. The wrist, the hand are no less significant than the rest, and for a viewer who can appreciate it, even a little finger is an excellent exponent of character, playing its role with pleasing accuracy. Only a petty mind, an artist who at most speaks and dresses as

such, looks solely for people in whom he recognizes the harmonious proportions of allegorical figures. For the true artist, as for the natural scientist, every type is interesting, and even the smallest muscle has its importance. If you do not like seeing old people whose features lack some dignified or delicate regularity, old people whom age has pitted and reddened like rust, go and see, in the pastels gallery, Chardin's self-portraits from when he was seventy. Above the enormous spectacles that have slipped down his nose, which they pinch with brand new lenses, his worn-out eyes turn upward in a diminished gaze, seeming to have done much looking, much bantering, and much loving, and to declare with a tender flourish: *Hé bien*, yes, I am old. Flecked with the gentle dimness of age, they have still kept their flame. But his eyelids, like clasps that have been overused, are fatigued, their rims red. Like the old garment that envelops his body, his skin has hardened and faded. Like the fabric, it has kept and almost heightened its pinkish tones, and is glazed here and there with a kind of golden nacre. And the wearing-out of the one always recalls the worn tones of the other, these being the tones of all things nearing their end: dying embers, rotting leaves, the setting sun, clothes worn thin, and men who pass on, infinitely delicate, rich, and soft. It is astonishing to see how the creasing of the mouth is exactly governed by the aperture of the eyes, which also dictates the wrinkling of the nose. The slightest fold in the skin, the slightest protrusion of a vein is the faithful, meticulous translation of three corresponding sources:

the character, the life, and the emotion of the moment. From now on I hope that in the street or at home you will incline with respectful interest towards these worn-out individuals who, if you can decipher them, will tell you infinitely more—more vividly and compellingly, too—than the most venerable manuscripts.

In the portrait we have just discussed, the carelessness of Chardin's attire, a night bonnet already on his head, makes him look like an old woman, and in another pastel of himself that Chardin has left us, approaches the droll outlandishness of an elderly English tourist. From the eyeshade pulled well down on his forehead to the Masulipatam scarf knotted around his neck, everything makes you want to smile, without any thought of hiding the fact, at this old eccentric who must be so intelligent, so crazy, so gentle and docile in accepting this raillery. Above all, such an artist. For every detail of this formidable and careless outfit that equips him for the night seems as much an indication of taste as it is a defiance of propriety. If the Masulipatam scarf is so old, it is because the old pink is softer. When you see the pink and yellow knots seemingly reflected in the pinkish-yellow skin, and recognize in the blue edge of the eyeshade the dark gleam of the steel-rimmed spectacles, your initial astonishment at the old man's surprising garb melts into gentle delight and the aristocratic pleasure of finding, in the apparent disorder of an elderly citizen's deshabille, the noble hierarchy of precious colors and the order of the laws of beauty.

But on looking more closely at Chardin's face in this

pastel drawing, you will hesitate, troubled by the uncertainty of his expression and not daring to smile or explain yourself or shed tears. When a young man stands before one who is old, there often arises—as it never does when he faces someone young—an inability to understand clearly the language at hand, which takes the form of an image yet is as swift, direct, and startling as a rejoinder, and which we call the play of features. Is Chardin looking at us with the bravado of an old man who does not take himself seriously, exaggerating—for our amusement or to show he is not fooled—the heartiness of a constitution as robust and a spirit as unruly as ever: "Ah! So you think you are the only youthful ones?" Or has our youth instead wounded his impotence, making him rebel with a passionate, futile defiance that is painful to behold? One could almost believe it, so serious is the eyes' liveliness and the quivering mouth. How many of us have been left wondering as to the meaning and intention of words spoken by an old person, and more especially, of certain expressions in his gaze, a quivering of the nose, a puckering of the mouth. Sometimes we smile when we look at old people, as we would in the presence of charming old lunatics. But at times we are fearful, too, as we are in the company of madmen. In a long lifetime a smile has so often turned on the mouth's hinges; anger or tenderness have so often rekindled the eyes' fire or sounded the voice's trumpet, and so often has vivid and ever-ready blood had to race all at once to the cheeks' transparency, that the mouth, its springs worn out, no longer opens with the effort, or does not properly

close when seriousness returns. The eyes' fire does not catch anymore, dimmed by smoke; cheeks no longer turn red, or else, stagnant as crimson lakes, redden excessively. The face no longer precisely translates each thought or emotion into the appropriate expression, omitting either the emotion, without which an affirmation becomes a joke, or the affectionate sarcasm, without which a boast becomes a threat; instead of being the figurative yet accurate language of our feelings, the face becomes a kind of rambling nonsense, saddening and indistinct, which sometimes, between two contradictory and disconnected expressions, leaves a sudden space for our disquiet, our comments, our thoughtfulness.

You have seen objects and fruits that look as alive as people, and people's faces, their skin, its fine down or unusual color, that have the look of fruit. Chardin goes further still, bringing together objects and people in these rooms that are more than an object, and even than a person perhaps, being the scene of their existence, the law of their affinities or contrasts, the restrained, wafted fragrance of their charm, their soul's silent yet indiscreet confidant, the sanctuary of their past. As happens when beings and objects have lived together a long time in simplicity, in mutual need and the vague pleasure of each other's company, everything here is amity. The pride of the old firedogs, loyal servants agleam with the honor of their masters, softens under the gently cordial gaze of the flame, and the dignified air of unmoving armchairs offers a welcome in this room where their lives slip by,

where every morning they are taken to the window to be dusted down, their punctual dotards' circuit or sluggish revolution always rounding off at exactly the same hour.

How many particular amities we come to know in a seemingly humdrum room, just as in a draft that stirs or drowses beside us we can see, when the sun falls across it, infinite, lively eddies. Look at *The Diligent Mother* or *Saying Grace*. There is amity between the sewing box and the old hound who comes each day to his usual spot, lying as he always does with his soft, lazy back against its cushioned fabric. It is amity that so naturally draws to the old spinning wheel, where they will feel so at ease, the dainty feet of the distracted woman whose body unwittingly complies with habits and affinities she unknowingly accepts. Amity, again, or marriage between the colors of the fire screen and those of the sewing box and skein of wool; between the inclined body and contented hands of the woman preparing the table, and the old tablecloth and dishes that have stayed intact, her careful hands still feeling, after so many years, their mild resistance where she always holds them; between this tablecloth and the light, which as a memento of its daily visits gives the cloth the softness of cream or of Flanders linen; between the light and the whole room it caresses, where it slumbers or wanders or cheerfully slips in unannounced, with such tenderness over so many years; between the warmth and the fabrics, between people and things, the past and this life, the bright and the dark.

So we come to the end of this journey of initiation into

the unknown life within the still life, which each of us can make if we let Chardin be our guide, as Dante was guided by Virgil. To go further we must now put ourselves in the hands of another master. Let us not yet cross the threshold to Rembrandt. From Chardin we have learned that a pear is as alive as a woman, a plain earthenware vessel as beautiful as a precious stone. The painter proclaimed the divine equality of all things before the mind that contemplates them and the light that embellishes them. He made us leave behind a false ideal so as to enter more broadly into the world of reality and find the beauty that is everywhere, no longer the languishing captive of convention or poor taste, but free, robust, and universal; in opening up the real world, he draws us out onto a sea of beauty.

With Rembrandt, reality itself will be overtaken. We will understand that beauty is not in objects, for then it would surely not be so profound or so mysterious. We shall see that objects in themselves are nothing, being hollow orbits whose light is the play of expression, the gleam borrowed from beauty, the divine gaze. We shall see in *The Philosopher in Meditation*, for example, how the waning light reddens a window like a furnace or paints it like stained glass, how it imposes upon a simple, everyday room the majestic, multicolored splendor of a church, the mystery of a crypt, the fear of the dark, of night, of the unknown, of crime. Likewise in *The Good Samaritan*, while at adjacent windows one figure in darkness slips away from the smile of another still in daylight, we will see the same bright shaft put earth in unison with sky and set humming

like a taut string the mysterious beauty of the far hill, the horse's back and a bucket lowered past the window, sending through these objects that are so common and familiar the gleam and frisson, so to speak, of the being we sense everywhere and can nowhere grasp, of this light that by day gives objects their beauty and by night their mystery; light which, as it draws away from objects, so alters their existence that we feel it must be their prime source, and that they themselves, during these beautiful, disquieting minutes, seem to pass through all the agonies of death. At such an hour we are all like Rembrandt's philosopher. We shudder on seeing the mysterious words written in fiery strokes on the wall. We turn our gaze—above the river or the dazzling or ruffled sea, above the glaze and glitter of blazing windows, the transfigured rooftops—to the sky, whose reflection on earth we recognize everywhere and will never know, even as we know it so well, it being the beauty, as well as the mystery and the unknown, in all we have ever seen. We too, like the philosopher, gaze at the sky, though we do not seek, as he does, an awareness of our joy or anguish, its essence or cause. Even the artist who painted the philosopher probably did not reason as the philosopher did. Like him, however, the artist did look at the sky, given that he painted it, and that is the only assertion I shall make by way of justifying myself to painters, since men of letters are always being accused of talking nonsense about paintings, of putting in them things that had never occurred to the artists themselves. But for me, what they did put in suffices.

With Chardin I have shown what the work of a great painter, through all that it was for him, can be for us. Far from being merely a display of particular skills, it is the expression of what was most intimate in his life and of things in their most profound aspect, and so it addresses our life, comes to touch upon it, slowly inclining us towards things and bringing us closer to the heart of them. I would like to add, for painters who always claim that men of letters are incapable of talking about painting, and obligingly ascribe to painters intentions they never had, that if painters do—and more specifically, if Chardin did—all that I have said, it was not at all intentional and was most likely done unawares. Chardin might have been greatly astonished to learn that he had so passionately revitalized a seemingly dead still life, and had relished oysters' cupped mother-of-pearl and cool seawater; that he had sympathized with the feelings of a tablecloth for a table, of sunlight for the cloth, of dimness for the light. It would likewise astonish a woman who has just given birth to hear a gynecologist describe the physiological process that she, with mysterious strength, has just carried through without knowing its nature; indeed, creative acts derive not from a familiarity with the rules that govern them but from an obscure, incomprehensible force that gains nothing from being explained. A woman does not need any knowledge of medicine in order to give birth, a man does not need to know the psychology of love in order to feel love, and he does not need to know the mechanism of anger in order to …

Plates

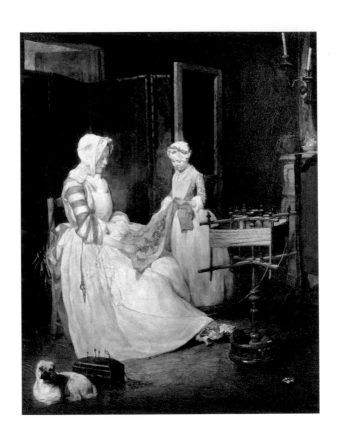

Jean Baptiste Siméon Chardin (1699–1779)

The Diligent Mother, c. 1740
Oil on canvas
19 ¼ × 15 ⅜ inches (49 × 39 cm)

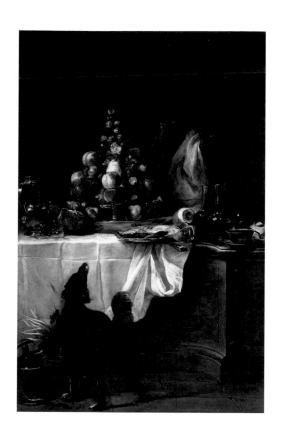

Jean Baptiste Siméon Chardin (1699–1779)

The Buffet, 1728
Oil on canvas
76 ⅜ × 50 ¾ inches (194 × 129 cm)

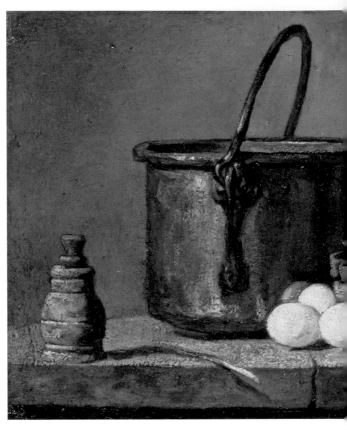

Jean Baptiste Siméon Chardin (1699–1779)

Kitchen Utensils, Cauldron, Saucepan, and Eggs, c. 1733
Oil on wood
6 ¾ × 8 ¼ inches (17 × 21 cm)

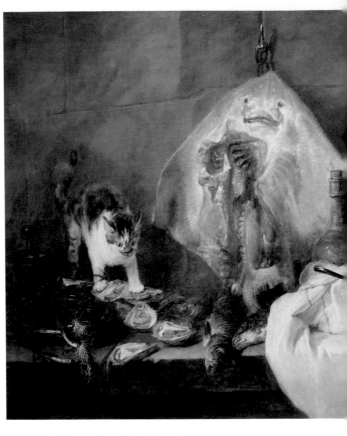

Jean Baptiste Siméon Chardin (1699–1779)

The Ray, c. 1725–1726
Oil on canvas
45 ⅛ × 57 ½ inches (114.5 × 146 cm)

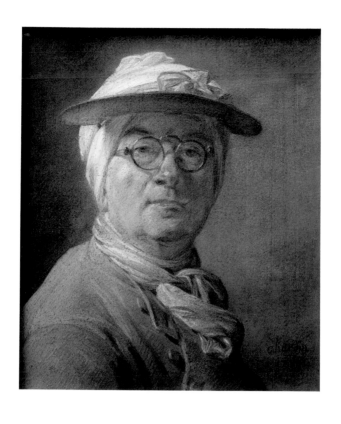

Jean Baptiste Siméon Chardin (1699–1779)

Self-Portrait with an Eyeshade, 1775
Pastel on blue paper
18 ⅛ × 15 inches (46.1 × 38 cm)

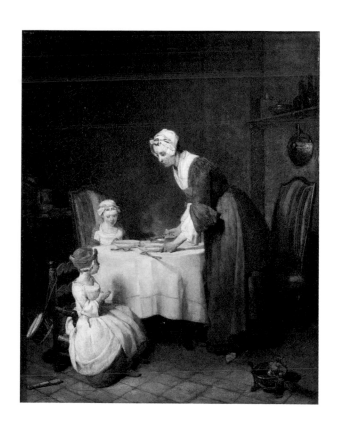

Jean Baptiste Siméon Chardin (1699–1779)

Saying Grace, c. 1740
Oil on canvas
19 ½ × 15 ⅛ inches (49.5 × 38.5 cm)

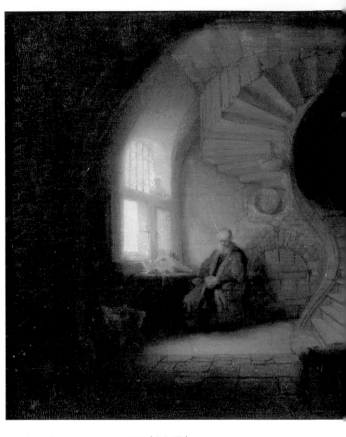

Rembrandt Harmensz van Rijn (1606–1669)

The Philosopher in Meditation, 1632
Oil on wood
11 × 13 ⅜ inches (28 × 34 cm)

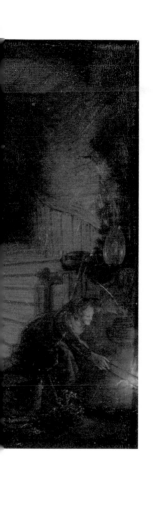

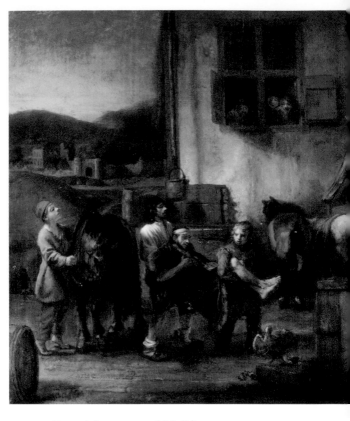

Constantijn Daniel van Renesse (1626–1680)

The Good Samaritan, c. 1650
Long attributed to Rembrandt Harmensz van Rijn
Oil on canvas
44 ⅞ × 53 ⅛ inches (114 × 135 cm)

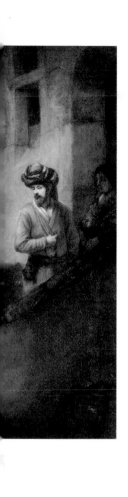

Afterword

Alain Madeleine-Perdrillat

In 1895, the probable date of this unfinished and untitled essay, Marcel Proust was twenty-four. That same year he began writing, at Beg-Meil in Brittany, the book we know as *Jean Santeuil*, which would also be left unfinished and untitled. He was on the threshold of his literary career, seeking his way between social writings, poetry, the novella or prose poem, and what he calls, referring to this essay, a "study of the philosophy of art, if that is not too pretentious a term"[1] (he had not yet discovered Ruskin). Until then he had written no more than a few pages of schoolboy compositions and some short texts that would be assembled the following year in the collection *Les Plaisirs et les Jours*, with a preface by Anatole France, marking his real entry into literature. That volume includes four somewhat rambling "Portraits de peintres," probably Proust's first writings on art. Composed in rhyming alexandrines following visits to the Louvre, they were clearly inspired by Baudelaire's "Les Phares" (indeed, one sees in these and in the four "Portraits de musiciens" that follow, the first signs of the gift for pastiche to which Proust would soon give free rein). The writing on these four painters—Aelbert Cuyp, Pieter Potter, Jean-Antoine Watteau, and Anthony Van Dyck, a somewhat incoherent grouping that reflects this formative phase—contains no mention of either Chardin or Rembrandt. Should we assume that Proust, who must have noted the works of Chardin and Rembrandt at the Louvre, decided they deserved more than rhyming lines? Or that, with regard to Chardin, poetry did not really lend itself to the evocation

of still life painting (a subject not found in "Les Phares")? Whatever the case, the fact that Proust launched into a major prose text points to an important decision on his part, an intuition as to where his real genius lay. One has the feeling that he understood at the time, indistinctly perhaps, that while the formal restraint of poetry undoubtedly allowed for the praise and celebration of works of art, it did not permit the elucidation of an experience which, although derived from art, in a sense surpassed it and therefore went beyond the purely aesthetic level; an analysis of this or that picture by Chardin was not going to be the object of Proust's attention. Unlike the "expert" or the pure aesthete, he would focus less on the actual works and their inherent qualities than on the way they relate to the world around him. This also suggests that the essay was written after reading Diderot's celebrated texts on painting; indeed, one finds in these the clear outline of an idea that Proust will elaborate: "It is there," noted the philosopher, "that one sees there are virtually no thankless objects in nature, and the point is to render them." [2]

Before returning to the question of how to make the most of works of art, it is worth noting Proust's *indirect* approach to his subject ("Take a young man of modest means . . ."). By addressing—almost challenging—his reader point-blank and inviting him to imagine a hypothetical figure, as if this were simply to demonstrate the veracity of a general rule, he achieves an objectivity that handily makes us forget the subjective nature of his ap-

proach. It is not at all a personal view that I, Marcel Proust, am putting forward, he implies, for I am only stating the facts; and it is not you, my readers—who doubtless know all this—that I am addressing . . . Why this particular contrivance? Why set the stage like this when it is easy to guess that the author was himself that young man once, and is assuming that his readers have all been, to some extent, such a person? In the first place, I believe this is quite simply because Proust is not attempting the sort of report on art usually written by journalists or critics, but rather a kind of *récit* or narrative. What comes to light here, not without a degree of awkwardness, is the urge to recount, and more specifically, to describe—an impulse to transpose visual experience into words so as to grasp it more fully and give it substance.[3] One cannot read the text without noticing a certain ambivalence, its author torn between wanting to convey an idea that is as yet vague, and the pleasure of composing well-turned phrases in the style of the Goncourt brothers (Proust's pastiches of them will come in due course). He seems to waver between the rigors of this endeavor and the liberties offered by literature. Whereas the future narrator of *In Search of Lost Time* will in a sense merge the unknowing young man and the knowing author by making us forget, though not entirely lose sight of, the latter, for now these two are kept artificially distinct. Perhaps this offers a clue as to why the text was left unfinished.

All of Proust's texts seem to turn, as if by magnetic attraction, towards the *magnum opus* that will be their

culmination, making it reasonable to consider them from that perspective. Indeed, the main idea of this youthful essay—which seems to take issue with all forms of aestheticism and theories of "art for art's sake"—is that one of the functions of beautiful art is to open our eyes to the beauty of the real world. This anticipates a celebrated passage in *The Way by Swann's* in which Swann, suddenly struck by the resemblance between Odette and the portrayal of Zipporah, daughter of Jethro, in a fresco by Botticelli in the Sistine Chapel, finds in this resemblance a justification for loving a woman who does not, in fact, appeal to him: "The words 'Florentine work of art' did Swann a great service. They allowed him, like a title, to bring Odette's image into a world of dreams to which she had not had access until then and where she was steeped in nobility." Once it had "for a foundation, the principles of an unquestionable aesthetic," Swann's love was secure.[4] Just as a painting by Chardin is meant to help the young man see the unsuspected charm of a bowl of fruit or a glass of wine in his kitchen, so Botticelli's fresco greatly helps the aging dilettante overcome his doubts about Odette's charms. Simple enough, it would seem. But as we know, Swann's adventure soon goes wrong, and had he pondered why, he would have found no one but himself to blame: he had not been able—or willing, perhaps—to see or know the real Odette de Crécy, who was just a common tart. What he had loved was imaginary; he had gradually and skillfully pieced together the idea of Odette from images in his cultural stock and mixed them

with vague fancies and traces of desire. Would things have been very different if the woman had been a model of virtue? Probably not: what Proust was pursuing was a vision, a dream. Here we can see that for Proust in his maturity the great danger posed by aestheticism lay not so much in its fostering an attachment to works of art, sometimes to the point where we genuinely prefer art to reality, as in leading us to believe that works of art can reveal that reality and enable us to discover an essence we would not have discerned on our own. Instead of introducing us to people and objects in the world, art can thus become an obstacle, further widening the gap between them and us by monopolizing and narrowing our attention.[5] But can the lesson learned from Swann—whose love is contrived but nonetheless genuine—be applied to the new way the "young man of modest means" will see the objects around him, thanks to Chardin? Will he not also discover in the end (though the essay has no ending) that these objects are never more than prosaic and everyday, and that their "true" beauty might come from being just what they are, integrated in a real setting, specifically placed and put to use?[6] In other words, is it really necessary to recruit Chardin, Vermeer, or Cézanne in order to see the beauty of a basket of fruit, a jug, or a loaf of bread? Is "raw" reality—insofar as that expression means something—at bottom so disappointing that it needs art in order to make it beautiful, and contrivance to make it tolerable, as Baudelaire would certainly have maintained, and as the young Proust intimates in this

unfinished essay? Such are the questions "Chardin and Rembrandt" indirectly raises—and this may be another reason for the device of the hypothetical character, which allows the author to stand aside and take the somewhat ambiguous position of a simple observer, one who gives instruction without saying where his knowledge comes from or explaining how he, Proust, who is not considered an artist (at least in this essay) discovered the beauty of everyday things, just as Swann never asks himself how he came to love and marry a woman who was "not his type" after she had repeatedly deceived him.[7]

Thus the text shifts back and forth between the perspectives of the young man and the artist, while the author-observer never ponders the "sharper awareness" said to distinguish the artist from other people, nor the inspiration or work of the artist, or what he makes of reality around him—even though this is where the real question lies. Hence the unfortunate impression in Proust's essay that there are simply two ways of looking at the world and two ways of looking at works of art. In looking at the world, there is the correct, inward way, that of the artist, and the wrong, exterior or superficial way, that of the young man. But is it certain that the painter, before picking up and wielding his brushes, sees *better* or more clearly than the young man? And how do we know what the latter sees, since he does not speak? Is it really necessary to have creative skills in order to feel in a deeper way the beauty in people, or in nature, or things? What is the author asking of the young man, if not that he be-

come an artist himself? As for the two ways of looking at art, there is the right way, which leads back to the "real" world, and the wrong way, which delights only in the attractiveness of the work. But does this really make sense? For what can we see in a Chardin painting if we do not recognize in it something from our own experience of objects, if it does not remind us, even vaguely, of some visual or tactile moment we have already experienced? The same can be said of a portrait by Van Dyck or a landscape by Claude Lorrain, which appeal to our familiarity with the human face or with nature. All of this suggests that for the author-observer, the young man who thinks he loves the works of those two artists is as incapable of seeing them as he is the paintings by Chardin.

Thus the unfortunate young man is entirely mistaken: unable *a priori* to cast his interior gaze on the world around him, he is no more able to do so *a posteriori*, after seeing the art that might have opened his eyes. His love of art is in essence only an illusion, or worse, snobbery. Hence the need for a kindly master, Proust, who takes on the worthy role of directing him. Here one becomes aware of a standpoint which, even though it reasonably rejects the intolerable complacency of *fin-de-siècle* aesthetics and boldly assigns to art the function of revealing the world, at the same time affirms a sharp division—set out in quasi-Manichean terms—between that which is inward and truly artistic, and that which is not. We are left unsatisfied because the text does not say how, through what conversion, the young man might come to see better than he

has until now, nor by what dispensation the author, for his part, has always known how to see so well. It is hard to believe that the latter's friendly injunction will bring about a change in the former.

The radical nature of this split, which inevitably leads to the idealizing of both the artist and the work of art, underpins a contradiction in the opening pages of the essay, one that does not seem to trouble Proust nor even come to his attention. At first he tells us that, unlike the young man, the artist is capable of feeling intense, immediate pleasure at the sight of the world around him (thanks to his "sharper awareness"), and, above all, of expressing that pleasure in a way that is "detached from the moment, deepened, eternalized." Thus a painting is a kind of extraction or elevation of objects and figures beyond time. It is difficult, however, to conceive of pleasure being "detached from the moment," or of how an image might reinstate it. This is harder still to understand when Proust next tells us that the artist, in a successful work, gives life to that which he portrays: "for him, metals and stoneware will come to life and fruits will speak," and later, that "still life will become, above all, alive." In his enthusiasm, the young writer attributes to the artist the marvelous ability to bring objects to life even as he eternalizes them, without seeing the inherent contradiction in this, given that the sense of being alive is linked to life's ephemeral, non-eternal quality. Here again there is a sense that some explanation is wanting, and that Proust has not gone beyond a simple intuition—one that will

prove fertile in *In Search of Lost Time*, when this innate contradiction is resolved through analyzing a memory, "a little bit of time in its pure state,"[8] thus eternalizing it. But for now the eloquence of the author's multiple descriptions is not enough to undo the error of the young man led astray by "a false ideal."

These problems may have been vaguely apparent to Proust, since he suddenly leaves Chardin and moves on to Rembrandt without any evident reason, as if needing to round out his argument by means of a different example.[9] "Beauty is not in objects," he now tells us, but in light, "which by day gives objects their beauty and by night their mystery"; this suggests that it is specifically light which the young man (who is no longer mentioned) does not know how to see. One might argue that Proust is only reprising and refining an earlier proposition regarding the artist's marvelous ability to see what ordinary mortals cannot, and that as his thinking turns back on itself the essay breaks off. In the unexpected passage on Rembrandt, however, there is a departure that undermines what has come before and might explain why the essay stops short: instead of the object, light itself is now seen as the true "upholder" of beauty; the author's thinking thus moves towards the dematerialization of beauty. This move brings with it greater subjectivity, because whereas things preserve an irreducible, objective reality, with light—especially the unnatural light of Rembrandt—we clearly enter the subjective realm. The theme of light provides a transition from the objective to the subjective,

and the latter will become the author's chief preoccupation in *In Search of Lost Time*. There we also find a kind of reversal of what is said in the essay, in the assertion that we should ask ourselves searching questions about the pleasure we get from works of art, instead of contenting ourselves with the way they embellish the world's outward aspects, or, like Swann, making them serve our illusions. In the final part of the novel, Proust says bluntly of art lovers: "They get more excited by works of art than real artists do, because their excitement, not being for them the result of hard, introspective investigation, bursts outward, overheats their conversation and makes them go red in the face." [10] If the novel's narrator were to meet the young man of the essay, his advice would not be to look at the world with an attentiveness renewed by contemplating the works of Chardin, but rather to seek within himself whatever might "clarify the nature of [his] enjoyment" of them. [11]

It is worth noting that the mood of the young man described at the beginning of the essay is very close to that of the narrator of *In Search of Lost Time* during the celebrated episode in which a madeleine is dipped in tea. The latter is overcome by the "gloomy day and the prospect of a sad future," [12] the former by the "domestic mediocrity" and the "ugliness around him." But whereas the young man can cure his ennui by listening to the good advice of a *professeur de beauté* (to adopt the term Proust used for Montesquiou) and can become an aesthete like Swann, the narrator in the novel, thanks to a sensation

as intimate as it is involuntary, is instantly seized by a "powerful joy," and will doubtless become an artist like Elstir or Vinteuil. Interestingly, of all the recollections that lead him to write, none derive from words or from visual art. The abandoned essay thus gives a measure of the distance Proust traveled from a simple critique of quite ordinary aestheticism to a supremely nuanced exploration of a wholly personal experience. However admirable they are, great works of art and eloquent expositions are not enough; they are sometimes misleading, and can never replace the constant recreative effort that beauty demands.

1 From a letter Proust wrote in 1895 to Pierre Mainguet, director of the *Revue hebdomadaire*, proposing this essay. In the Bibliothèque de la Pléiade edition, Pierre Clarac cites the letter and notes, "it seems that Proust never sent nor even finished this article. He may have included the pages on Rembrandt at a later date." Cf. Marcel Proust, *Contre Sainte-Beuve*, preceded by *Pastiches et mélanges* and followed by *Essais et articles* (Paris: Gallimard, Bibliothèque de la Pléiade, 1971), p. 885. The piece was not published during Proust's lifetime and first appeared in *Le Figaro littéraire* on March 27, 1954.

2 Denis Diderot, *Salon de 1765*, in the "Savoir-Lettres" collection (Paris: Hermann, 1984), p. 121. Another indication that Proust had read Diderot is his use of "Masulipatam" to refer to the knotted scarf Chardin wears in his *Self-Portrait with Spectacles* (pastel, in the Louvre). Diderot employs this unusual word in the *Salon de 1765*, but in reference to a still life by Chardin and to another by Roland de La Porte (*Salon*, p. 121 and pp. 172–173).

3 In a text written in 1905 and dedicated to Montesquiou, Proust reproves
 the author of *Maîtres d'autrefois*, Eugène Fromentin, for having only
 "rarely in his books, despite all the wealth of detailed explanations, pro-
 found reasoning and technical touches, enabled us to see a picture": cf.
 Proust, *Contre Sainte-Beuve*, p. 518.

4 Marcel Proust, *In Search of Lost Time*, vol. 1: *The Way by Swann's*, trans.
 Lydia Davis (London: Penguin, 2003), p. 227.

5 In an untitled piece not published during his lifetime, which I believe
 slightly postdates the essay on Chardin, Proust envisages this danger:
 "Once you have seen Chardin, not only do you find beauty in a homely
 meal, but you imagine that poetry is in simple meals alone and look away
 when you see jewels." Marcel Proust, "Poetry, or the Mysterious Laws,"
 in *Against Sainte-Beuve and Other Essays*, trans. John Sturrock (London:
 Penguin, 1994), p. 148.

6 Cf. Martin Heidegger's curiously lyrical discussion of Van Gogh's *A Pair
 of Shoes* in Heidegger's "The origin of the work of art" in *Basic Writings:
 from Being and time (1927) to The task of thinking (1964)*, trans. David Far-
 rell Krell (San Francisco: HarperSanFrancisco, 1993), pp. 158–162.

7 Even after his disillusion and his marriage, Swann persists in seeing
 Odette through the filter of Botticelli's works: cf. Marcel Proust, *In Search
 of Lost Time*, vol. 2: *In the Shadow of Young Girls in Flower*, trans. James
 Grieve (London: Penguin, 2003), pp. 193–194. Here aestheticism becomes
 a defense against the disappointments of reality.

8 Marcel Proust, *In Search of Lost Time*, vol. 6: *Finding Time Again*, trans. Ian
 Patterson (London: Penguin, 2003), p. 180.

9 The far from obvious pairing of these two painters might have arisen from
 Proust's reading of earlier texts (notably a letter from Grimm to Diderot) in
 which Rembrandt is mentioned in the context of comments on Chardin's
 Portrait of the Painter Joseph Aved. The painting itself, however, only came
 into the Louvre's collection in 1915. In *L'art du XVIIIe siècle* (the definitive
 edition had a second printing in 1894), Edmond and Jules de Goncourt
 also make passing reference to Rembrandt in connection with Chardin.

10 Proust, *In Search of Lost Time*, vol. 6: *Finding Time Again*, p. 200.

11 Ibid.

12 Proust, *In Search of Lost Time*, vol. 1: *The Way by Swann's*, p. 47.

MARCEL PROUST (1871–1922) was a French writer, critic, and essayist. He is best known for his novel *À la recherche du temps perdu* (*In Search of Lost Time*), which was published in seven volumes between 1913 and 1927, and is considered one of the most important literary works of the twentieth century.

JENNIE FELDMAN is a freelance writer and translator. She has written two collections of poems, *The Lost Notebook* (2005) and *Swift* (2012), and translated Jacques Réda's poetry, *Treading Lightly: Selected Poems 1961–1975* (2005), as well as his autobiographical work, *The Mirabelle Pickers* (*Aller aux mirabelles*) (2012). She is co-editor and translator, with Stephen Romer, of *Into the Deep Street: Seven Modern French Poets 1938–2008* (2009). All five books are published by Anvil Press Poetry, London. She lives in Jerusalem and Oxford.

Born in Paris in 1949, ALAIN MADELEINE-PERDRILLAT served as the director of communication for the Réunion des musées nationaux for many years. He teaches at the Institut national d'histoire de l'art (INHA) and is the author of an important monograph on Georges Seurat (1990), a study of the letters of Nicolas de Staël (2003), and numerous articles and essays on literature, painting, and photography.

"Ekphrasis" is traditionally defined as the literary representation of a work of visual art. One of the oldest forms of writing, it originated in ancient Greece, where it referred to the practice and skill of presenting artworks through vivid, highly detailed accounts. Today, "ekphrasis" is more openly interpreted as one art form, whether it be writing, visual art, music, or film, that is used to define and describe another art form, in order to bring to an audience the experiential and visceral impact of the subject.

The *ekphrasis* series from David Zwirner Books is dedicated to publishing rare, out-of-print, and newly commissioned texts as accessible paperback volumes. It is part of David Zwirner Books's ongoing effort to publish new and surprising pieces of writing on visual culture.

OTHER TITLES IN THE *EKPHRASIS* SERIES

On Contemporary Art
César Aira

Something Close to Music
John Ashbery

The Salon of 1846
Charles Baudelaire

My Friend Van Gogh
Émile Bernard

Strange Impressions
Romaine Brooks

A Balthus Notebook
Guy Davenport

Ramblings of a Wannabe Painter
Paul Gauguin

*Thrust: A Spasmodic Pictorial
History of the Codpiece in Art*
Michael Glover

Visions and Ecstasies
H.D.

Mad about Painting
Katsushika Hokusai

Blue
Derek Jarman

Kandinsky: Incarnating Beauty
Alexandre Kojève

Pissing Figures 1280–2014
Jean-Claude Lebensztejn

The Psychology of an Art Writer
Vernon Lee

Degas and His Model
Alice Michel

28 Paradises
Patrick Modiano and
Dominique Zehrfuss

*Any Day Now: Toward a
Black Aesthetic*
Larry Neal

Summoning Pearl Harbor
Alexander Nemerov

Letters to a Young Painter
Rainer Maria Rilke

The Cathedral Is Dying
Auguste Rodin

Giotto and His Works in Padua
John Ruskin

Duchamp's Last Day
Donald Shambroom

Dix Portraits
Gertrude Stein

Photography and Belief
David Levi Strauss

The Critic as Artist
Oscar Wilde

Oh, to Be a Painter!
Virginia Woolf

Two Cities
Cynthia Zarin

Collection and Photography Credits

Chardin and Rembrandt
Marcel Proust

Translated from the French
"Chardin et Rembrandt"

Published by
David Zwirner Books
520 West 20th Street, 2nd Floor
New York, New York 10011
+ 1 212 727 2070
davidzwirnerbooks.com

Editor: Lucas Zwirner
Translator: Jennie Feldman
Project assistant: Molly Stein
Proofreaders: Anna Drozda,
Jessica Loudis
Designer: Michael Dyer / Remake
Production manager: Jules Thomson
Color separations: VeronaLibri,
Verona
Printing: VeronaLibri, Verona

Typeface: Arnhem
Paper: Holmen Book Cream,
80 gsm; GardaMatt, 130 gsm

Publication © 2016
David Zwirner Books
First published 2016.
Second printing 2017.
Third printing 2024

Translation © 2016 Jennie Feldman
Afterword © 2016
Alain Madeleine-Perdrillat

Special thanks to Le Bruit du temps
for permission to reprint the after-
word by Alain Madeleine-Perdrillat
from its 2009 French edition

ISBN 978-1-941701-50-8

Library of Congress
Control Number: 2016949229

Printed in Italy

David Zwirner Books

ekphrasis